TRADITIONAL COOKING

VENICE

FAVOURITE RECIPES

SIME | BOOKS

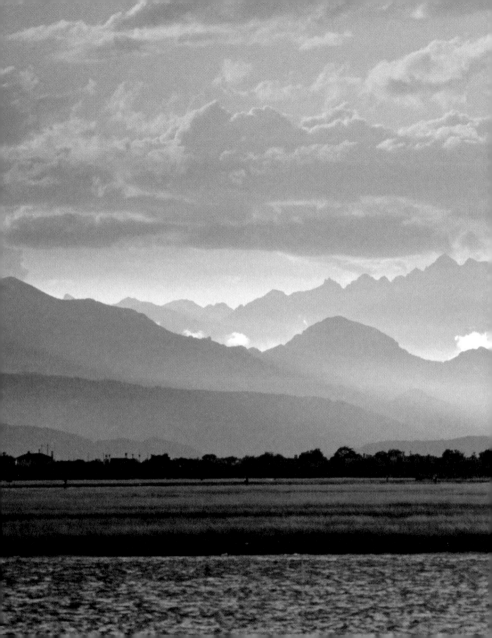

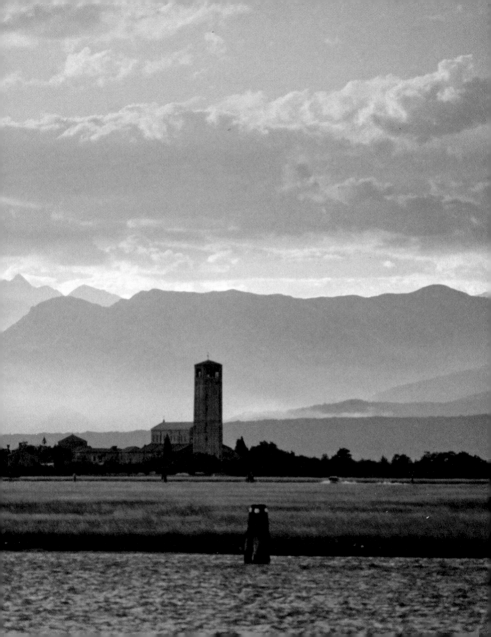

CONTENTS

Authentic Venice.. 7

Antipastos and "cicchetti" ... 13

First courses... 33

Second courses... 49

Desserts .. 67

Glossary .. 86

Index of recipes ... 90

Recipe difficulty:

■ ◻ ◻ easy

■ ■ ◻ medium

■ ■ ■ hard

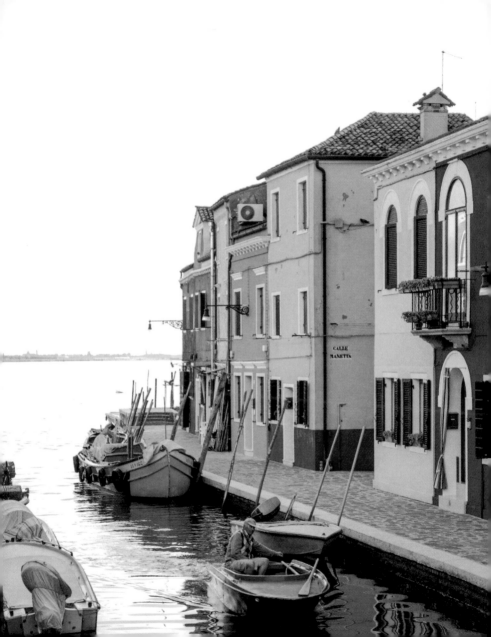

AUTHENTIC VENICE

Venice has always been a bustling trading city. Its cuisine is the most profound expression of a territorial identity and was not immune to contaminations by other cultures. The need to preserve food during long sea journeys and strong links with the Far East, the origin of the city's imported spices, generated recipes with unexpected flavours. Nonetheless, the flavour of Venetian dishes reveals something more that its commercial past. To discover what that is, you have to sail to the lagoon's islands, where the restaurants offer authentic traditional Venetian cuisine, what you might call "native Venice". Cooks busy in their quest to revive ancient dishes have recovered local products that include the once-popular "*barena* herbs". A "*barena*" is a saltmarsh periodically submerged by the tides and its "salty soil" allows only certain types of plants to prosper, with the result that they reflect this unique habitat in their flavour. An awareness of the territory is fundamental for discovering the authentic flavours of this cuisine.

Another unique event you may discover is the "*caigo*", the typical Venetian lagoon fog so thick it is impossible to see beyond the end of your nose. When it starts, life in the lagoon seems to be suspended in time as the boats stop and connections between Venice and the mainland are interrupted. What better time to chat with the fishermen, who are also landlocked. Maybe one of them will tell you about the time he painted his house as turquoise as the

colour of the sea. How lovely it looked next to the coral red of his neighbour's house and, above all, how it helped to disperse some of this foggy grey that washes out the sky and the sea, and sometimes even your mood ... So why not go and have an "*ombra*" of wine and eat a "*cicchetto*" with it. In the tavern you will even bump into the porter who should have been delivering fruit to Rialto but is stuck like everyone else, because of the *caigo*. "At least the flavours," he says "don't lose their colour, even when the fog's so thick you can't see your hand in front of your face."

But when it is possible to fish, the lagoon provides a bounty of varieties that are the secret of Venetian cuisine: pilchards, striped bream, eel, and a huge selection of shellfish. Sadly, the fishermen who know this area like the back of their hands are now few and far between, so the lagoon's fishing secrets are no longer handed down. It is tough being a fisherman today: young folk move to the mainland, where life is easier, yet for those who choose to stay, there is a craft to learn and, more than that, an entire world to be protected.

Luckily there are the women to rely on, those worker bees always on the go, with no time to feel sorry for themselves. When the housework is done, you will see them sitting in the lanes, with their friends, concentrating hard on their pillow lace out in the sunshine, even though their eyesight is no longer what it was.

Once the grey fog has lifted, the islands bloom in every shade of green. At last you see Mazzorbo, Sant'Erasmo, Torcello, Murano, Vignole... What a surprise to observe their lavish vegetable plots, and even vineyards, flourishing in a setting you might have imagined as stony, but with a soil redolent with clay and salt, and vegetables exploding with flavour that beggars belief. As early as the 1600s, the Franciscan mapmaker Vincenzo Maria Coronelli wrote: "Amongst the islands that border the Lagoon of Venice, note that of Sant'Erasmo, with its lovely vines and gardens, which provide such a quantity of perfect fruit and vegetables to the city..." This is the story of the lagoon, the pantry storing all the flavours of Venice.

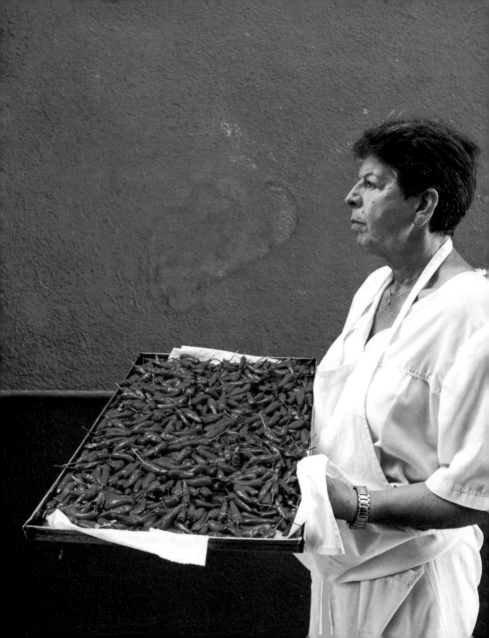

ANTIPASTOS AND "CICCHETTI"

Venetian Aperol Spritzer ... 14
Mini meatballs .. 16
Crostini with creamed salt cod .. 18
Grilled scallops .. 22
Queen scallops .. 24
Raw scampi with pink pepper ... 26
Spider crab salad .. 28
Boiled musky octopus ... 30

Ingredients for one
glass:
- 2 parts prosecco
- 1 part Aperol
- a splash of soda
- half a slice of ripe
 orange
- ice

VENETIAN APEROL SPRITZER

Put enough ice in a flute to fill at least half the glass.

Pour in the prosecco and add a splash of soda. Lastly, add the Aperol: any amount as long as there is twice as much prosecco as there is Aperol.

Stir gently, add the half slice of orange and serve.

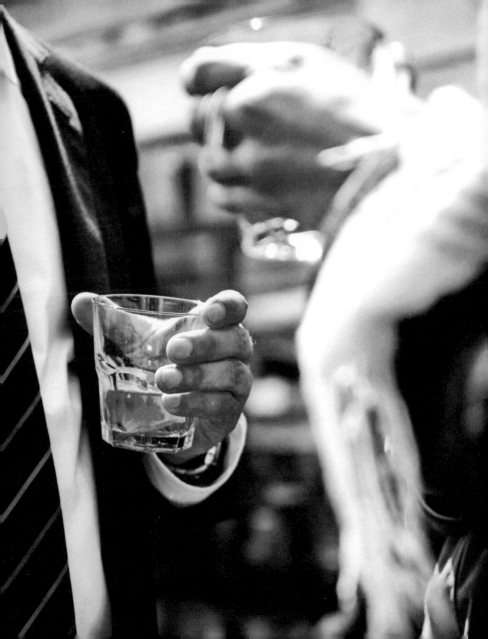

MINI MEATBALLS

Serves 4:
- 400g (1 lb) of mixed
 ground meat
- 3 eggs
- 40g (½ cup) of grated
 parmigiano reggiano
- 20g (2 tbsps) of flour
- 1 sprig of chopped
 parsley
- breadcrumbs
- extra virgin olive oil
- salt
- pepper

Place the ground meat in a bowl with the whole eggs, grated cheese, flour, chopped parsley, a pinch of salt and freshly-ground pepper, and a handful of breadcrumbs.

Mix thoroughly until all the ingredients are well blended. The mixture should be smooth and firm enough to shape small meatballs; if it is too moist, just add breadcrumbs.

Cover the bowl and leave to stand for at least one hour so the flavours blend.

Pour some breadcrumbs on a plate and start making bite-sized meatballs from the mixture. Roll in the breadcrumbs then fry in the hot oil. Turn the meatballs and continue to fry for 5-6 minutes until the outside is golden and crispy. Serve piping hot.

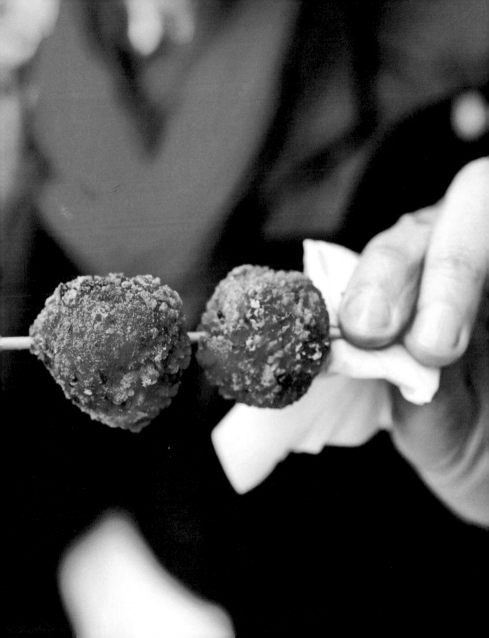

Serves 4:
- 250g (8 oz) of salt cod or stockfish, ready soaked and boned
- extra virgin olive oil
- bay leaf
- 1 lemon
- salt
- pepper
- chopped parsley
- sliced bread

CROSTINI WITH CREAMED SALT COD

Put the salt cod pieces in a pot of cold water, add salt, the bay leaf and lemon juice, and bring to a boil. Cook for 20 minutes, stirring occasionally.

When the fish is cooked, drain and keep aside a little of the cooking water in case the final cream has to be softened.

Place the salt cod in a bowl and use a wooden spoon (not a blender) to stir vigorously, pouring the oil a little at a time so it is mixed in well. This procedure is known as "mante-catura". Continue to stir until the cream is firm and smooth. Add salt and pepper to taste. To adjust the texture to taste, simply add a few spoons of the fish cooking juices.

Arrange the slices of bread, preferably hot, on plates and spread with the creamed salt cod.

Tip
Traditionally the cream is also spread on slices of white polenta toasted on a griddle

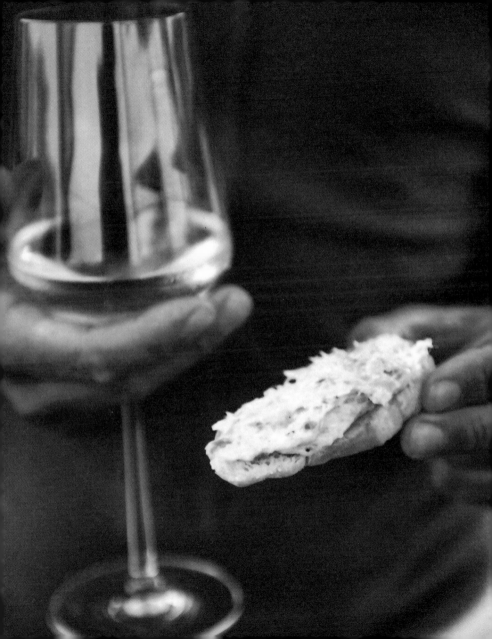

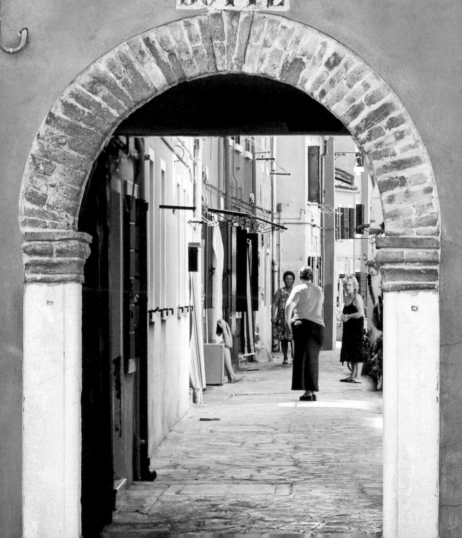

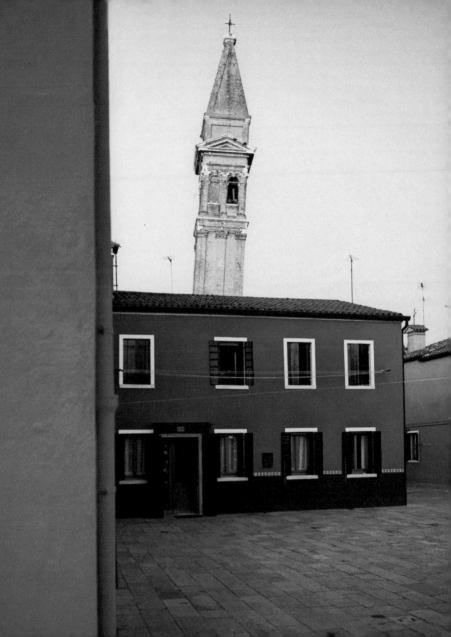

GRILLED SCALLOPS

Serves 4:
- 8 scallops
- extra virgin olive oil
- salt
- pepper
- 4 lemon wedges

Remove the scallops from their shells and wash carefully with cold water, removing the brown frill and leaving the white flesh with the red coral attached. Then clean the 4 shells, dry and keep aside.

Preheat the griddle or a non-stick pan and when the surface is very hot, fry the scallops for 4-5 minutes, turning so they do not burn.

In the meantime, arrange 2 shells on each plate. Garnish the plates by adding a bed of tender salad leaves under the shells.

When the molluscs are ready, place one on each shell, drizzle with olive oil, add a pinch of salt and one of pepper to taste.

Serve with lemon wedges.

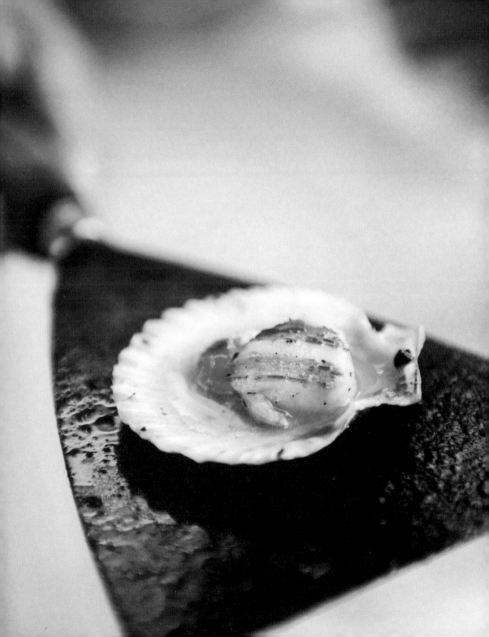

Serves 4:
- 16 queen scallops
- extra virgin olive oil
- 1 clove of garlic
- 1 glass of dry white wine
- 1 sprig of chopped
 parsley

QUEEN SCALLOPS

Clean the queen scallops carefully with cold water, including the shells.

Sauté the clove of garlic in a pan with a little oil and when hot add the queen scallops.

Sauté for a few minutes then pour in the white wine. Leave to evaporate for a few minutes, cover the pan and cook for 5-6 minutes.

Turn off the heat and sprinkle with plenty of parsley.

Serve hot, with a few tablespoons of cooking juices.

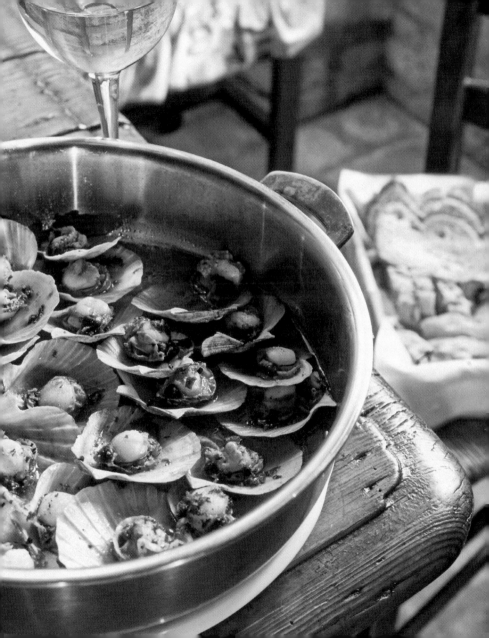

Serves 4:
- 16 scampi
- extra virgin olive oil
- pink peppercorns

RAW SCAMPI WITH PINK PEPPER

Carefully clean the scampi with cold water.

Remove the final section of the carapace, leaving the head.

Arrange 4 scampi on each plate, then drizzle with extra virgin olive oil and sprinkle with pink peppercorns.

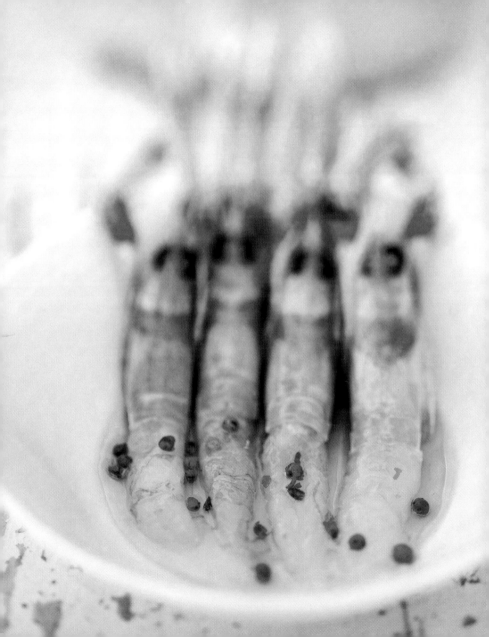

SPIDER CRAB SALAD

Serves 4:
- 4 spider crabs weighing
 500-800g (18-30 oz)
 each
- 4 tbsps of extra virgin
 olive oil
- 1 lemon
- 1 sprig of chopped
 parsley
- salt
- pepper

Bring a large pan of water to the boil and immerse the spider crabs for 7-8 minutes. When boiled, remove from the water and leave to cool.

When they reach room temperature, open the carapace and extract the meat, ensuring the coral-coloured eggs are removed and put aside in a bowl. Now remove the claws from the body and press them with a heavy knife or a nutcracker, being careful not to crush the meat inside too much as it will have to be removed.

Rinse the top of 4 shells well and keep aside.

Tear the crab meat roughly into pieces of the same size, then season with salt, pepper, a little oil, lemon juice, and chopped parsley. Mix carefully and divide the mixture into the shells, adding any eggs in the middle.

Place each crab on a plate and serve.

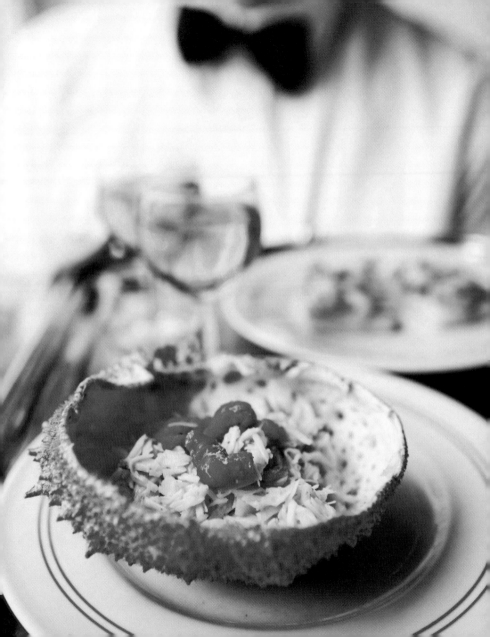

BOILED MUSKY OCTOPUS

Serves 4:
- 12 musky octopus
- coarse salt
- 2 stalks of celery
- 1 fish stock cube
- several wedges of lemon
 to taste

Turn the octopus inside out and remove the inner sac. Wash thoroughly under cold water to remove sand from the tentacles.

Pour 6-8 pints of cold water into a pot, with a handful of coarse salt, celery and the stock cube.

Bring to the boil then, being careful to avoid scalding, take each octopus by the head and dip just the tentacles into boiling water until they curl.

At this point immerse the entire octopus and cook for 25 minutes. Drain and serve plain or with a drizzle of extra virgin olive oil.

Plate up with wedges of lemon.

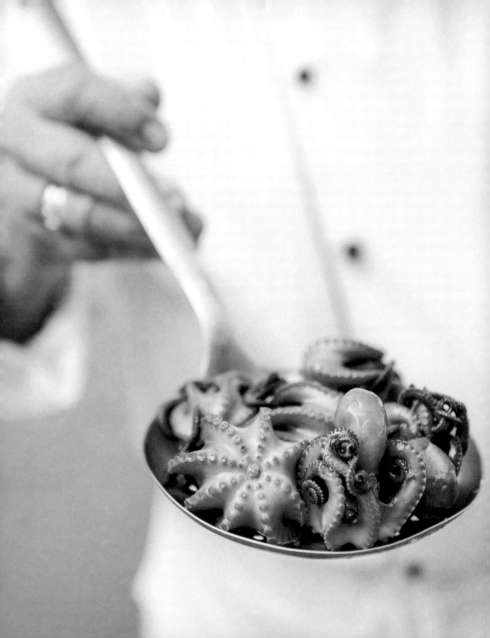

FIRST COURSES

Rice and peas .. 34
Cuttlefish ink tagliatelle with mantis shrimp 36
Bigoli pasta in salsa .. 39
Pasta and beans ... 40
Artichoke risotto .. 42
Tagliolini pasta with spider crab and cherry tomatoes 44
Spaghetti with mussels in tomato sauce 46

RICE AND PEAS

Serves 4:
- 320g (1¾ cups) Vialone Nano rice
- 1kg (2 lbs) of fresh shelled peas
- 1 stock cube
- 1 chopped onion
- 1 knob of butter
- grated parmigiano reggiano
- extra virgin olive oil
- salt
- pepper

How to make the stock
Prepare a pan with 3 pints of water and the stock cube; bring to the boil.

How to prepare the risotto
Sauté the onion and the rice in a pan with a dash of olive oil.

Toast the rice for 1 minute then add the peas. Slowly drizzle in the hot stock for the entire cooking time.

When cooked, after about 15-18 minutes, add salt if required, then stir in the butter and parmigiano. The rice should be creamy, "all'onda", which means it will slide to the rim of the plate if it is tilted.

Stir vigorously and serve.

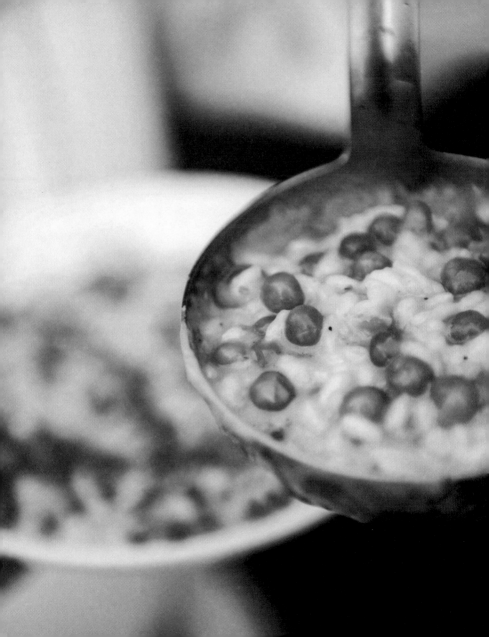

CUTTLEFISH INK TAGLIATELLE WITH MANTIS SHRIMP

■ ■ ■

Serves 4:
For the pasta
- 200g (1¾ cups) of
 all-purpose white flour
- 2 eggs
- 2 cuttlefish ink sacs
For the sauce
- 16 mantis shrimp
- 2 whole chillis
- 14-16 Pachino tomatoes
- 1 glass of dry white wine
- 1 clove of garlic
- extra virgin olive oil
- chopped parsley
- salt

How to make the pasta

Make a well of flour on a pastry board, add the eggs, cuttlefish ink and a pinch of salt. Knead the dough until it is soft and smooth, sprinkling flour on the board to stop it sticking. Form a ball and let the dough rest for an hour covered with a cloth or a basin.

If no pasta maker is available to draw the dough, use a rolling pin, sprinkling with plenty of flour. When the dough has been rolled out, fold it over on itself and cut strips of about ½ cm (⅒ inch) in width. The rolled dough unravels into tagliatelle.

How to make the sauce

Thoroughly wash the mantis shrimp in cold water, making an incision along the entire length of the back to remove the armour, and the head if preferred.
Pour a little oil in a pot and add the garlic and two chillis. For a stronger taste, crumble the chillis instead of leaving them whole.

When the oil is hot, add the mantis shrimp and leave to brown for a few minutes. Pour in the wine and when it has evaporated, add the tomatoes sliced lengthwise.

>>

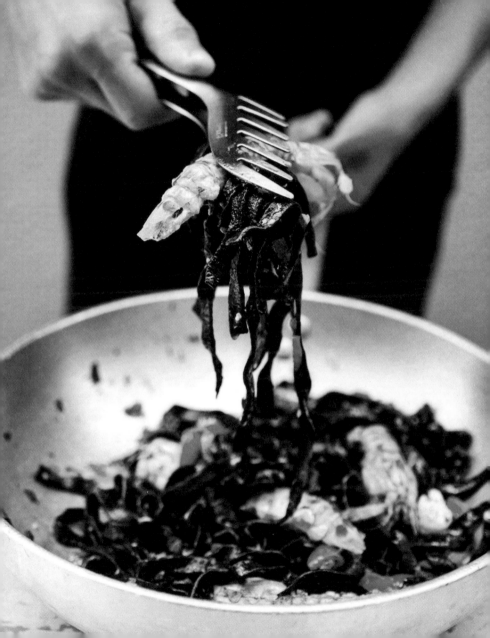

<<

Add salt and pepper, and cook for a few minutes.

Bring plenty of salted water to the boil in a pot and add the pasta. Drain when al dente and tip into the pot of sauce to finish cooking, so that the pasta mixes well with the sauce. Serve piping hot.

Tips
When making fresh pasta it is always a good idea to have extra flour to hand because more may be needed depending on the type of eggs used. Also, it is always useful to dust the pastry boards and utensils with flour so the pasta does not stick.

When cooking cuttlefish, store any unused ink in the freezer and thaw at room temperature when needed.

BIGOLI PASTA IN SALSA

■ ◻ ◻

Serves 4:
- 400g (1 lb) of bigoli pasta
- 8 salted anchovies or sardines
- 2 onions
- 1 dl (½ cup) of extra virgin olive oil
- salt
- black pepper

Pour the oil into a wide skillet. Slice two large onions very finely, place in the skillet, cover and sauté over a low heat but do not brown; add a few spoons of hot pasta water if they dry out too much.

Meanwhile prepare the anchovies by washing and boning; when the onions are transparent, add the anchovies to the skillet. Leave to cook until the anchovies disintegrate completely, then add a pinch of salt.

Meanwhile cook the bigoli in boiling salted water until al dente. Drain the pasta very quickly and toss it in the anchovy sauce with plenty of black pepper.

Did you know that...
Traditionally, "bigoli in salsa" is eaten on days of abstinence like Christmas Eve, Ash Wednesday and Good Friday.

PASTA AND BEANS

Serves 4:
- 400g (1 lb) of Lamon beans
- 200g (8 oz) of ditalini pasta
- 1 onion
- 1 clove of garlic
- 2-3 tomatoes
- 1 chilli pepper
- salt
- pepper

Put the onion, garlic, tomatoes and chilli pepper in a tall pot. Add enough cold water to cover the ingredients completely. In a pressure cooker the beans require 40 minutes to cook; in an ordinary saucepan, cover with a lid and allow to cook until the beans are soft.

Separately, pour the ditalini into a pot of boiling salted water.

When the beans are cooked, remove the garlic and just over half of the beans, and leave aside. All remaining ingredients in the saucepan should be blended thoroughly to make a soft cream.

Drain the ditalini al dente and add them to the cream along with the whole beans kept aside. Add salt and pepper to taste, then serve piping hot.

Tip
To make the soup tastier, drizzle with extra virgin olive oil directly in the bowl. Serve with croutons on the side.

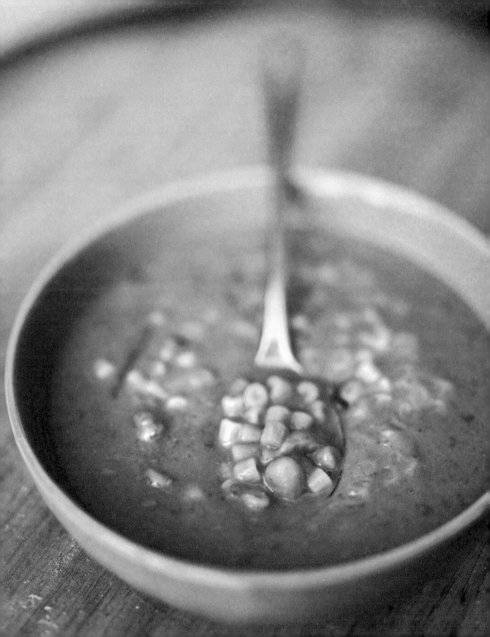

ARTICHOKE RISOTTO

Serves 4:
- 320g (1¾ cups) Vialone Nano rice
- 8 purple Sant'Erasmo artichokes (castraure)
- 2 shallots
- ½ cup of dry white wine
- 1 litre (2 pints) of chicken stock
- 3 tbsps of extra virgin olive oil

Prepare the artichokes by removing the outer leaves and trimming the tip from the rest. Slice into rounds, sauté in a skillet with a tablespoon of olive oil to soften them, then keep aside.

Peel and chop the shallots, then sauté these also, in a large pot with the rest of the oil. After a few minutes add the rice and stir. Continue cooking until the rice is no longer translucent.

Add the white wine and leave to evaporate.

Cook, gradually adding the chicken stock and stirring all the while for at least 18-20 minutes.

Now add the fried castraure, stirring well but gently. Season with salt and pepper and serve immediately.

Serves 4:
- 400g (1 lb) of egg
 tagliolini
- 2 medium-size spider
 crabs
- 20-25 cherry tomatoes
- ½ glass of dry white
 wine
- 1 clove of garlic
- extra virgin olive oil
- salt
- black peppercorns to
 grind

TAGLIOLINI PASTA WITH SPIDER CRAB AND CHERRY TOMATOES

Wash the spider crabs thoroughly in cold water and boil in salted water for about 20 minutes. Leave to cool and remove the pulp from the carapace and claws.

Pour a little oil into a pot and add garlic. When hot, add the spider crab flesh and sauté for a few minutes. Turn the heat up high, add the wine and leave to evaporate. Add the chopped tomatoes and leave to simmer for a few minutes. Add salt and pepper and turn off the heat.

Cook the pasta in a pan and drain a few minutes before it is ready, but pouring a ladle of the cooking water into the sauce along with the pasta. Finish cooking and serve hot.

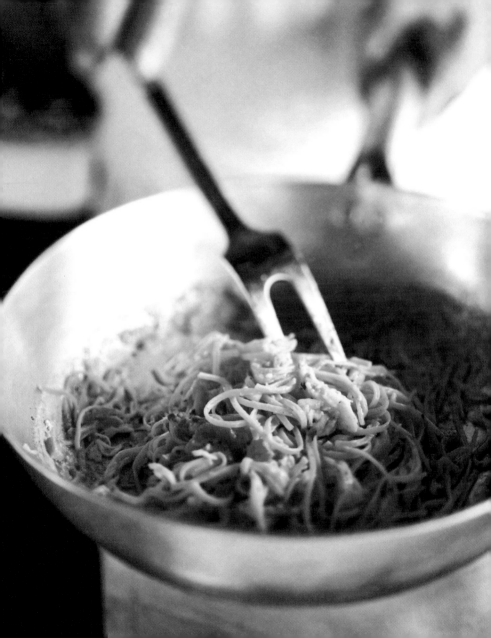

SPAGHETTI WITH MUSSELS IN TOMATO SAUCE

Serves 4:
- 400g (1 lb) of spaghetti
- 1kg (2 lbs) of mussels in their shells
- 1 can of chopped tomatoes
- 1 glass of dry white wine
- 1 clove of garlic
- extra virgin olive oil
- salt
- pepper

Thoroughly wash the mussels, also scrubbing the shells. Discard those not fully closed.

Pour a little olive oil in a pot with garlic. When the oil is hot, add the mussels and leave to simmer for a few minutes before adding the white wine. Cover the pot and cook the mussels until they open. Discard those that are still closed. Remove the mussels, leave aside 12 shells, and shuck the rest. Keep aside some of the cooking juices.

Drizzle olive oil into a skillet. When it is hot add the tomatoes and cook for 10 minutes. Add the shucked shellfish with half a ladle of stock. Add salt and pepper to taste, and simmer for 5-6 minutes on a high heat. Cook the spaghetti in a pot of boiling water. 4-5 minutes before the pasta is al dente, drain and pour into the sauce. Stir well and finish cooking. Plate up 4 portions of pasta and garnish with the mussel shells that were kept aside. Serve hot.

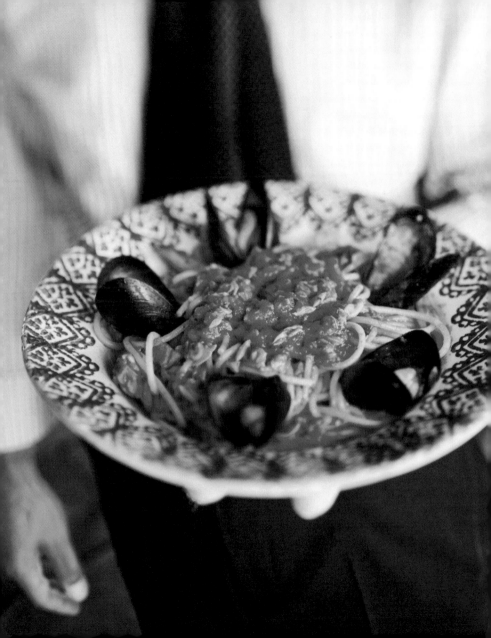

SECOND COURSES

Pilchards in sweet and sour 'saor' 50
Venetian-style liver .. 52
Stewed savoy cabbage ... 53
Cuttlefish in ink with polenta .. 54
Boiled periwinkles .. 56
Sea bream in a salt crust ... 60
Mackerel, salicornia and tomato confit 62
Baked crab ... 64

PILCHARDS IN SWEET AND SOUR 'SAOR'

Serves 4:
- 20 fresh boned pilchards
- 400g (1 lb) of white onions
- vinegar
- white wine
- 4 bay leaves
- 40g (1½ oz) raisins
- extra virgin olive oil

Slice the onions finely and place in a pot with a little oil. Sweat over a low heat for a few minutes.

Continue by pouring in half a glass of vinegar and half a glass of white wine. Add the bay leaves. Cook until the liquid is absorbed.

Place the boned pilchards on a baking sheet and cook for 2 minutes at 190 °C (375 °F).

Now place in a dish and cover completely with the onions and raisins.

Leave for a few hours and then serve.

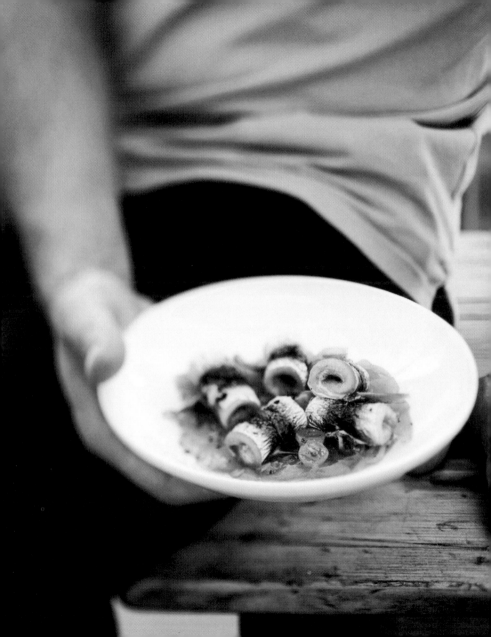

VENETIAN-STYLE LIVER

Serves 4:
- 500g (1 lb) of calf's liver
- 2 white onions
- butter
- extra virgin olive oil
- vinegar
- salt
- pepper

Slice the onions finely and sweat on a low heat in a skillet with oil and butter, stirring occasionally to prevent them sticking to the pan.

Meanwhile, remove the skin from the surface of the liver and slice the meat into thin strips. When the onions are cooked, which takes about 15 minutes, add the vinegar and the liver, and cook for no more than 5 minutes at a high heat.

Season with salt and pepper, and serve hot.

Tip
To make this recipe lighter use only olive oil to cook everything. Moreover, Venetian-style liver should always be served piping hot and never reheated as the meat will become tough.

STEWED SAVOY CABBAGE

Serves 4:
- 1 savoy cabbage
- 1 onion
- 1l (2 pints) vegetable
 stock
- rosemary
- white vinegar
- extra virgin olive oil
- salt
- pepper

Remove the outer leaves and cut the cabbage into strips.

Pour the oil into a saucepan, chop the onion and sauté.

Add the cabbage, salt, pepper, cover and cook. Simmer and while cooking, lift the lid and mix well. The cabbage will cook slowly in its own juices. If it is slow to cook, just add a little vegetable stock.

Cooking takes about 45 minutes and the cabbage should stew (so it is "sofegada"). At this point, season with a sprig of rosemary and, if preferred, a few tablespoons of white vinegar.

Serves 4:
- 4 medium-size cuttlefish
- 1 clove of garlic
- 1 glass of dry white wine
- extra virgin olive oil
- salt
- black pepper

CUTTLEFISH IN INK WITH POLENTA

Wash the cuttlefish, remove the skin and central bone. Clean thoroughly in water until they become white. Be careful not to break the sacs that contain the black liquid, which must be recovered and put aside.

Heat a pan with a little oil and when hot add the cuttlefish. Fry and after about 5 minutes add the wine. Leave to evaporate on a gentle heat for 15 minutes. Add salt and pepper to taste.

When the cuttlefish is almost cooked, add the sacs of black ink with half a glass of water.

When cooked, serve with a slice of white polenta.

Tip
If the shape of the whole cuttlefish is unappealing, remove the mouth, eyes and tentacles after washing, and cut the flesh into thin strips.

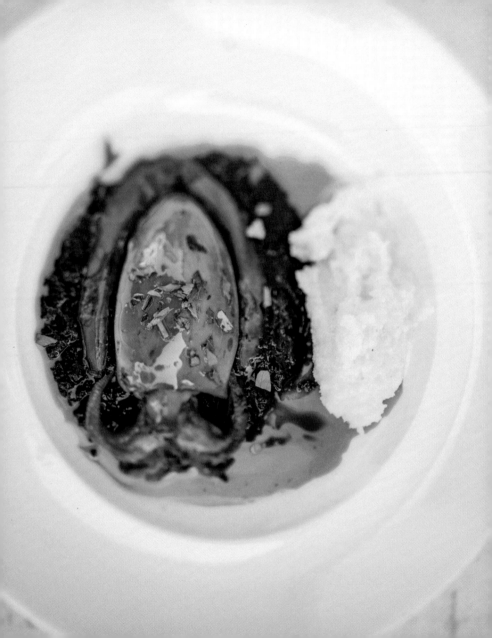

BOILED PERIWINKLES

Serves 4:
- 2kg (4-5 lbs) periwinkles
- extra virgin olive oil
- coarse salt
- black peppercorns to
 grind

Wash the periwinkles in a very large bowl.

When clean, tip into a large pot and cover completely with cold water; add a handful of salt and boil for about 90 minutes.

When cooked, turn off the heat and drain. Shell the periwinkles while still hot and serve warm, drizzled with olive oil and pepper to taste.

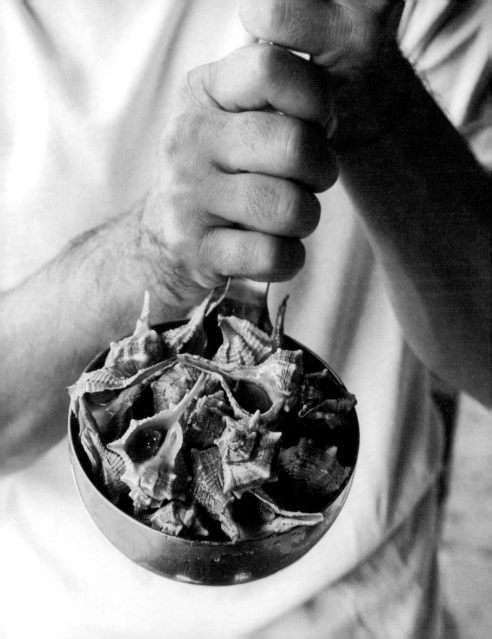

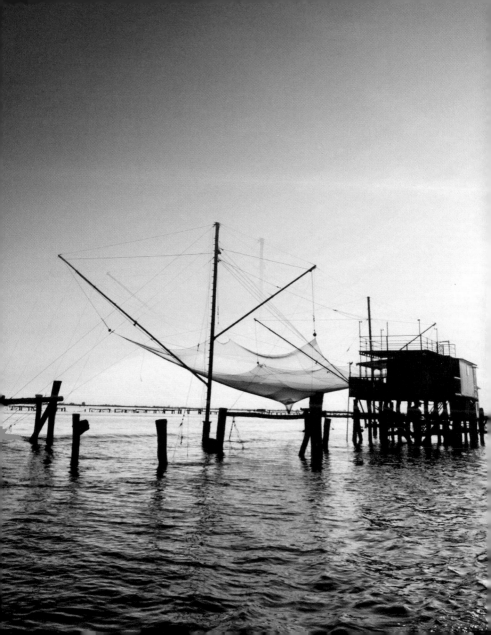

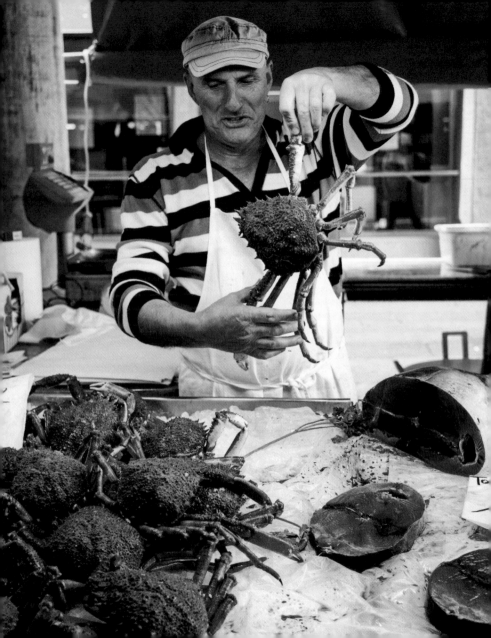

Serves 4:
- a whole sea bream weighing 1.5kg (3 lbs)
- 1.5kg (3 lbs) of coarse salt
- 500g (1 lb) table salt
- 5 egg whites

SEA BREAM IN A SALT CRUST

Clean the sea bream thoroughly, gut and remove the gills. The fish should not be scaled as the scales protect the flesh during cooking.

In a bowl mix the coarse and table salts carefully with the egg whites. Use an oven tray large enough to accommodate the whole fish and cover the bottom with the salt and yolk mixture, rest the fish on it then cover with more mixture in the shape of the fish.

The upper layer must be about 1 cm (¼ inch) high. Bake in a hot oven at 180 °C (355 °F) for 30-40 minutes, until the salt crust turns a golden colour.

Remove from the oven, break the salt crust and serve the fish.

Tip
To make the fish tastier, place herbs inside it before cooking, and mix the same chopped herbs with the coarse salt.

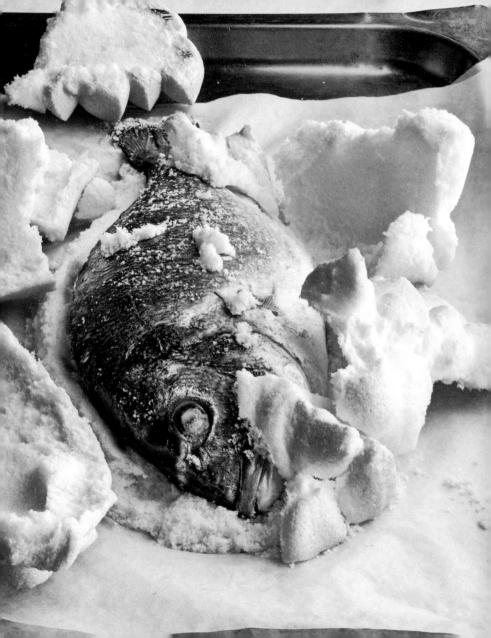

Serves 4:
- 4 mackerel filets
- 200g (8 oz) of blanched salicornia
- 4 San Marzano tomatoes
- superfine sugar
- 4 cloves of garlic
- extra virgin olive oil
- salt
- pepper

MACKEREL, SALICORNIA AND TOMATO CONFIT

Bring the water to the boil in a saucepan, add the tomatoes and scald for a minute.

Remove the tomatoes from the water and peel off the skin, cut in half and remove seeds.

Place on a baking sheet and dress with extra virgin olive oil, garlic, salt, and the superfine sugar, then bake for 2 hours at 90 °C (195 °F).

Cook the mackerel in a saucepan with extra virgin olive oil and a bay leaf at 70 °C (160 °F) for about 8 minutes.

Serve the mackerel filet with 2 halves of tomato confit and a sprinkling of crunchy salicornia.

BAKED CRAB

Serves 4:
- 4 medium or 2 large
 crabs
- 1 sprig of rosemary
- breadcrumbs
- salt
- pepper

After washing the crabs thoroughly with cold water, break into pieces and remove the entrails.

Place the pieces in an ovenproof dish and add salt, pepper, breadcrumbs, and a sprig of rosemary then bake at 180 °C (355 °F) for 20 minutes.

Serve the crabs hot.

Tip
A different method is to boil the crabs in a pan of water for about 10 minutes. Remove the flesh from the shell, wash the shells and then replace the pulp (discarding the offal).

Prepare a liquid sauce with parsley and chopped garlic, pepper, salt and olive oil; add two tablespoons of breadcrumbs and stir well until the mixture is smooth. Pour the sauce over the crab.

Bake at 200 °C (390 °F) until the surface is golden brown (3-4 minutes).

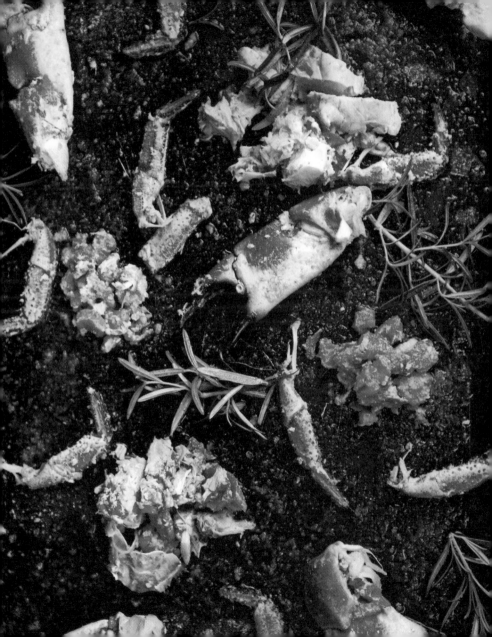

DESSERTS

Galani .. 68
Burano bussolà cookies ... 70
Tiramisu .. 72
Zaleti ... 76
Lemon, vodka and prosecco sorbet 78
Cream of pumpkin with jujubes 80
Venetian fritters .. 82

GALANI

■ ■ ◻

Ingredients:
- 300g (2¼ cups) of flour
- 60g (½ cup) of
 granulated sugar
- 2 eggs
- 60g (3 tbsps) of butter
- a glass of grappa
- ½ a glass of milk
- vegetable oil (or lard)
 for frying
- 50g (½ cup) of icing
 sugar
- salt

Melt the butter in a small saucepan.

Make a well of flour and pour in the eggs, melted butter, granulated sugar, milk, small glass of grappa, a pinch of salt, and work together until the dough is smooth and compact.

Form a ball and leave to rest for 15 minutes covered with a cloth or wrapped in kitchen film.

Then roll the dough out into sheets as thin as possible. Using a serrated wheel cut diamond shapes and make two incisions in the centre.

In a wide, tall skillet heat plenty of oil and when it is very hot, immerse two dough diamonds at a time, frying until golden and bubbles form on the surface. Remove with a skimmer, drain and place on kitchen roll to remove excess grease.

Arrange on a serving dish and sprinkle with icing sugar.

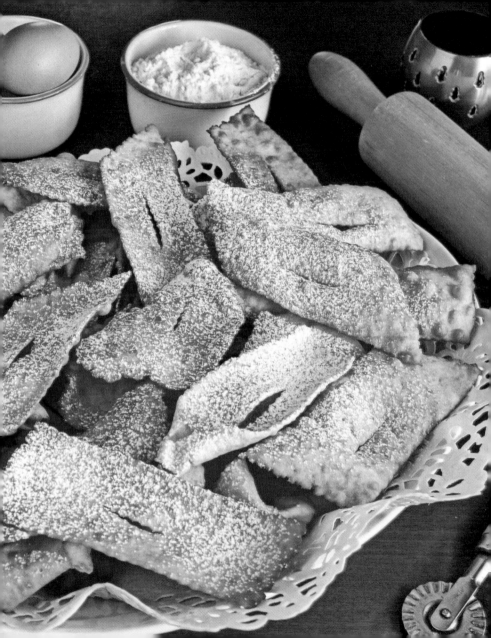

BURANO BUSSOLÀ COOKIES

Ingredients:
- 500g (4¼ cups) of
 all-purpose white flour
- 150g (⅔ cup) of butter
- 300g (1½ cups) of sugar
- 6 egg yolks
- vanillin
- rum or lemon flavouring

Make a well of flour and add sugar, salt, flavourings, and egg yolks. Begin kneading and add the butter. Knead until all the ingredients are well mixed and the dough is smooth, so it does not crumble.

Now shape the cookies as preferred. Traditionally are of two types: a circle (bussolà) and an "s".

Then bake at 170 °C (340 °F) for about 15-20 minutes (depending on the shape), until the surface is a good golden brown. To give the bussolà a golden sheen, create some steam inside the oven to "sweat" the dough.

The colour comes from the egg yolks, so the cookies will be different shades of yellow.

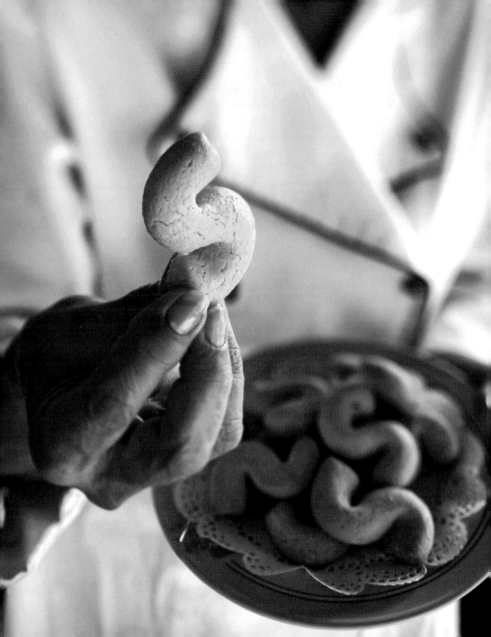

TIRAMISU

■ ■ ◻

Ingredients:
- 5 whole eggs
- 250g (2½ cups) of sugar
- 500g (18 oz) of mascarpone
- 1 teaspoon of Marsala
- sponge fingers
- 6 cups of espresso coffee
- unsweetened cocoa powder
- salt
- quare mould

Prepare the coffee and pour into a bowl.
Add 2 tablespoons of sugar while it is still warm,
and a teaspoon of Marsala.

Use an electric whisk to mix the sugar and egg yolk
in a bowl. When the mixture is very creamy, add the
mascarpone a little at a time, to obtain a smooth cream.

Whip the egg whites in a bowl. To whisk into perfect
peaks, add a pinch of salt. When the contents are compact
and do not move when the bowl is shaken, gently add the
mascarpone cream.

Prepare the mould and line the bottom with the sponge
fingers soaked in coffee. Take care not to soak too much
or the sponge fingers will disintegrate; if they are not
soaked enough, they will stay crunchy. Pour a layer of
cream of about 1 centimetre (¼ inch). Add a second layer
of sponge fingers, placing them at right angles to the
first layer, and finish with the cream. Leave to cool in a
refrigerator for a few hours.

Sieve a little cocoa on the surface before serving.

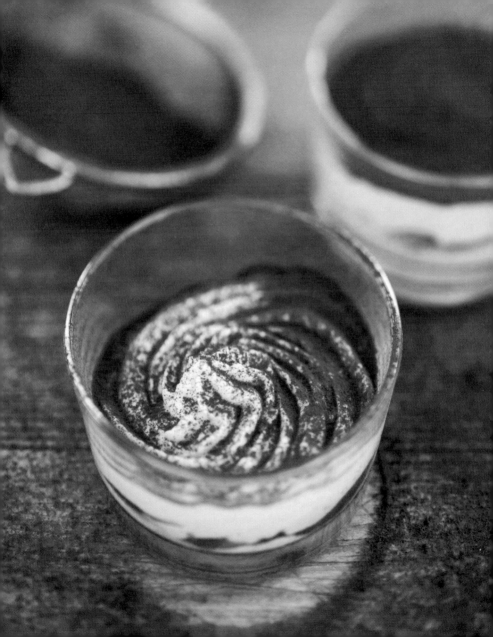

ZALETI

■ ■ ▢

Ingredients:
- 350g (2½ cups) of yellow cornmeal
- 200g (1½ cups) of all-purpose white flour
- 2 whole eggs
- 100g (½ cup) of butter
- 150g (¾ cup) of sugar
- 4g (3 pinches) of dry yeast
- raisins to taste
- vanillin
- salt

Put the butter, salt, vanilla, and sugar in a bowl and work well until the mixture is smooth and very white.

Add the eggs one at a time, stirring constantly.

Combine the two sifted flours and the dry yeast.
Mix everything well and then add the raisins.

Form dough balls the size of a walnut and squash slightly, then shape into a diamond outline. Bake for 20-25 minutes at 145 °C (295 °F). When golden, remove from the oven and allow to cool.

Did you know that…
"Zaleti", from the Venetian word for yellow, get their name from the golden hue of the cornmeal used.

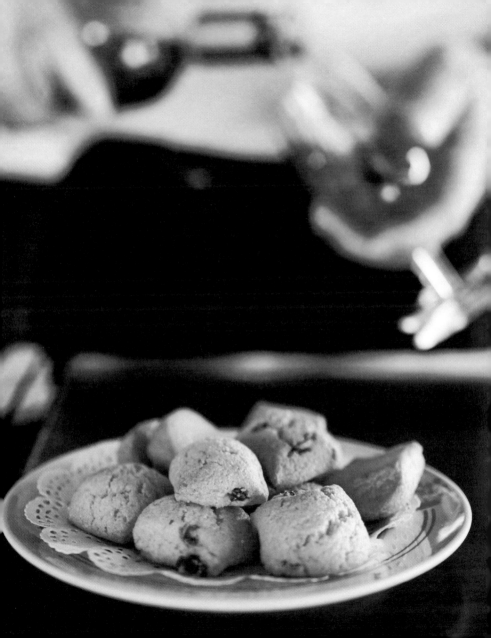

Serves 4:
- 3 tbsps of pouring cream
- 15cl (10 tbsps) of prosecco
- 5cl (3 tbsps) of vodka
- 4 tbsps of lemon ice cream

LEMON, VODKA AND PROSECCO SORBET

Put the pouring cream, prosecco and vodka in the freezer half an hour before starting to prepare the sgroppino.

In a tall container beat together the lemon ice cream, pouring cream and prosecco. Add the vodka and stir again. When the mixture is frothy, pour into chilled glasses.

Serve immediately with dry patisserie.

Tip
Prepare a tee-total sgroppino for children by replacing the alcohol with mineral water.

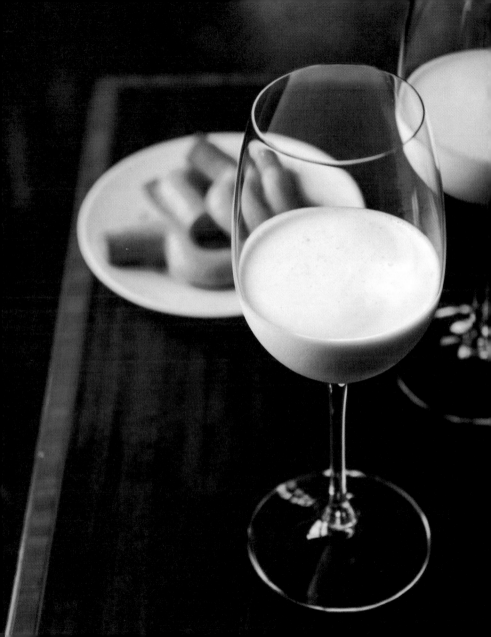

Serves 4:
- 400g (14 oz) pumpkin flesh
- 24 jujubes
- 400ml (14 fl. oz) milk
- 160g (¾ cup) of sugar
- 1 vanilla pod
- 4 slabs of puff pastry

CREAM OF PUMPKIN WITH JUJUBES

Pour the milk, sugar (keep aside 3 tablespoons), vanilla, and pumpkin into a saucepan. Bring to the boil and continue to cook until the pumpkin is tender.

When cooked, remove the vanilla pod and blend well to make a smooth cream.

Pour the 3 tablespoons of sugar into a pan and caramelize the jujubes.

Pour the cream into 4 bowls, divide the jujubes and garnish with a slice of crisp puff pastry.

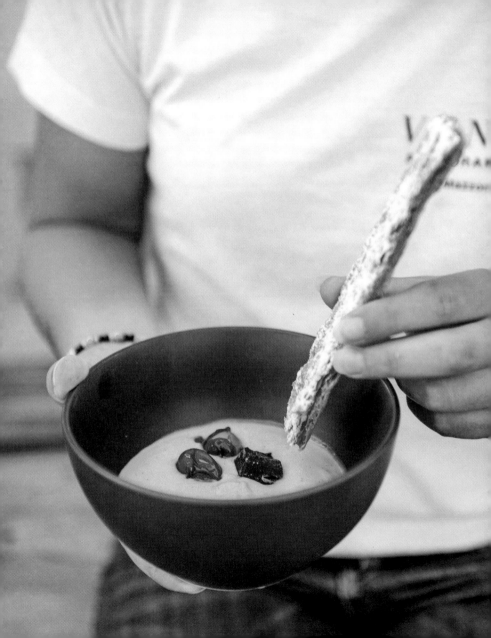

VENETIAN FRITTERS

■ ■ ▢

Ingredients:
- 500g (3¾ cups) of flour
- 130g (5 oz) of currants
- 2 eggs
- 80g (⅖ cup) of granulated sugar
- 40g (3 pinches) of dry yeast
- 2 small glasses of grappa
- grated lemon zest
- a pinch of ground cinnamon
- icing sugar
- salt
- vegetable oil for frying

Soak the currants in a glass of grappa and dilute the dry yeast in half a glass of warm water.

In a bowl mix the flour, eggs, milk, granulated sugar, grated lemon zest, a pinch of cinnamon and one of salt. Mix well, then add the dissolved yeast and the currants with grappa. Cover the bowl with a teacloth and leave the dough to rise until it doubles its volume.

In a wide, tall skillet heat plenty of oil and when it is very hot, then pour spoons of the mixture into the oil, leaving plenty of room between them so the fritters do not stick. Fry on one side then turn and fry on the other until they turn a hazelnut colour. Remove with a skimmer and drain on kitchen roll.

Sprinkle with icing sugar and serve.

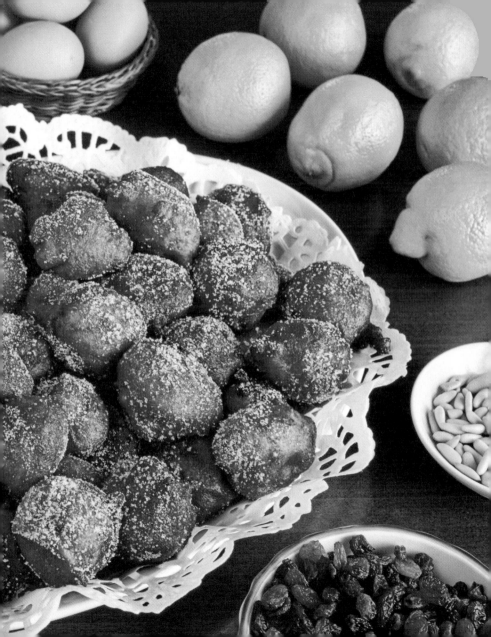

Bigoli
Typical Venetian pasta, resembling big spaghetti but longer and quite rough, so sauces and condiments coat better. Originally made with wheat flour, water and salt, but bigoli can now also be found in variants using whole flour or with the addition of eggs.

Jujube
The fruit of the jujube tree, quite widespread in Veneto, and also known as a Chinese date. The best-known use of this fruit is in the preparation of "jujube soup", an ancient liqueur so sweet that Italians say they are "in jujube soup" when they are especially happy.

Saor
Literally meaning "flavour", in Venetian cuisine "saor" is a sweet and sour sauce used on fish. The need to use vinegar on fish to highlight its qualities and preserve it at length is a common practice in various culinary traditions. In particular, for Venice it was important to preserve food for long sea journeys. In this case, the recipe is enriched with onion from the lagoon's vegetable plots, used for its antibacterial properties, and with currants used widely in Venetian cuisine thanks to the city's trade links with the Far East.

Sgroppino

This is an alcohol-based lemon sorbet. The recipe was evolved for aristocratic tables as an interlude between fish and meat dishes, to prepare the palate to taste the different recipes, but today it is usually consumed at the end of the meal as a digestif.

Spritzer

An alcoholic drink made from white wine, usually prosecco, and sparkling water or soda, which can be topped up to taste with Aperol, Campari, Select or Cynar. It seems that the name derives from the fact that during Habsburg rule Austrian soldiers diluted local wines with a dash of water to offset the high alcohol content (from the German "spritzen", which means "to spray").

MOLLUSCS

Great mediterranean scallop *(Pecten jacobaeus)*
A mollusc also known as a "coquille St Jacques".

Musky Octopus *(Eledone moschata)*
Is a mollusc similar to octopus.

CRUSTACEANS

Mantis Shrimp *(Squilla Mantis)*
A crustacean with a greyish-white shell with a pinkish tinge and two reddish-purple oval spots, similar to eyes, on its tail.

Spider Crab *(Maja squinado)*
A crustacean that resembles a crab but with much longer legs. The name derives from the combination of the Venetian dialect words "granso" (crab) and "seola" (onion).

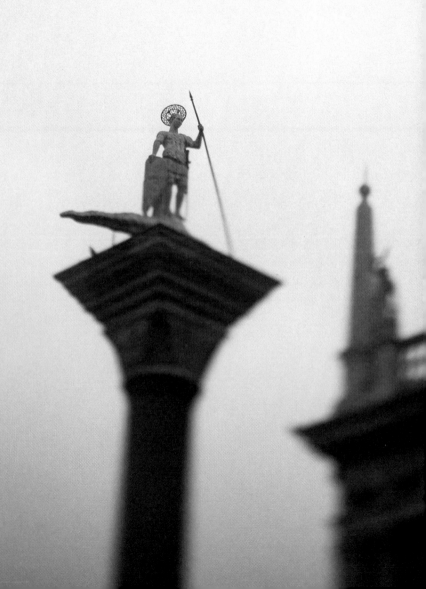

INDEX OF RECIPES

B
Boiled musky octopus.. 30
Boiled periwinkles... 56
Burano bussolà cookies ... 70

C
Cream of pumpkin with jujubes 80
Crostini with creamed salt cod.. 18
Cuttlefish in ink with polenta... 54
Cuttlefish ink tagliatelle with mantis shrimp 36

G
Galani .. 68
Grilled scallops ... 22

L
Lemon, vodka and prosecco sorbet 78

M
Mackerel, salicornia and tomato confit 62
Mini meatballs.. 16

P
Pasta and beans.. 40
Pilchards in sweet and sour 'saor' 50

Q

Queen scallops ... 24

R

Raw scampi with pink pepper 26
Rice and peas .. 34

S

Sea bream in a salt crust .. 60
Spaghetti with mussels in tomato sauce 46
Spider crab salad .. 28
Stewed savoy cabbage ... 53

T

Tagliolini pasta with spider crab and cherry tomatoes ... 44
Tiramisu .. 72

V

Venetian Aperol Spritzer ... 14
Venetian fritters ... 82
Venetian-style liver ... 52

Z

Zaleti .. 76

Photographs:
All images were taken by **Laurent Grandadam** except for:

Stefano Brozzi p. 20
Matteo Carassale p. 25, p. 84-85
Colin Dutton p. 89
Olimpio Fantuz p. 2-3
Stefano Renier p. 69, p. 83
Sandro Santioli p. 75
Stefano Scatà p. 61
Giovanni Simeone p. 92-93

Images are available at **www.simephoto.com**

An excerpt of **"Venezia in Cucina - The flavours of Venice"**
ed. 2012 SimeBooks

Text and Editing
Cinzia Armanini
Editing
Alberta Magris
Translation
Angela Arnone
Photoeditor
Giovanni Simeone
Design and Layout
Jenny Biffis
Prepress
Fabio Mascanzoni

ISBN 978-88-95218-75-5

Sime srl
Tel. +39 0438 402581
www.sime-books.com

An excerpt of:

"VENEZIA IN CUCINA THE FLAVOURS OF VENICE"

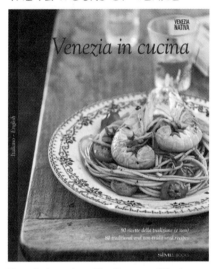

Venezia in cucina - The flavours of Venice
80 ricette della tradizione (e non)
80 traditional and non-traditional recipes

Edited by Cinzia Armanini - Alberta Magris
Photographs by Laurent Grandadam

Hardback
Italiano/English
288 pages - 26,00 €
19,5x23,5 cm
ISBN 978-88-95218-42-7

www.sime-books.com